Draw
Landscapes

NORMAN BATTERSHILL

Series editors: David and Brenda Herbert

A & C Black • London

First published in 1980
New style of paperback binding 1995
By A&C Black Publishers Limited
38 Soho Square, London W1D 3HB
www.acblack.com

Reprinted 1999, 2003, 2007 (twice)

ISBN: 978-0-7136-8304-2

Cover design by Emily Bornoff

Printed in China by WKT Company Limited

This book is produced using paper that is made from wood grown in managed,
sustainable forests. It is natural, renewable and recyclable. The logging and
manufacturing processes conform to the environmental regulations of the country of origin.

Contents

Introduction

Everyone is able to draw. How you develop this ability depends on you and, of course, your tutor.

Constant practice and effort are essential. My own learning comes from drawing out of doors in different media as consistently as I possibly can. The subject does not matter—I draw whatever interests me. In this book I have tried to pass on what I have learnt and to encourage you to discover for yourself the pleasure and satisfaction of landscape drawing.

The act of drawing teaches you to observe beyond casual looking and to become more acutely aware of what you see around you. Landscape provides an infinitely varied and rewarding subject.

Making a start

Learning to draw is largely a matter of practice and observation—so draw as much and as often as you can, and use your eyes all the time.

The time you spend on a drawing is not important. A ten-minute sketch can say more than a slow, painstaking drawing that takes many hours.

Carry a sketchbook with you whenever possible, and don't be shy of using it in public, either for quick notes to be used later or for a finished drawing.

To do an interesting drawing, you must enjoy it. Even if you start on something that doesn't particularly interest you, you will probably find that the act of drawing it—and looking at it in a new way—creates its own excitement. The less you think about how you are drawing and the more you think about what you are drawing, the better your drawing will be.

The best equipment will not itself make you a better artist—a masterpiece can be drawn with a stump of pencil on a scrap of paper. But good equipment is encouraging and pleasant to use, so buy the best you can afford and don't be afraid to use it freely.

Be as bold as you dare. It's your piece of paper and you can do what you like with it. Experiment with the biggest piece of paper and the boldest, softest piece of chalk or crayon you can find, filling the paper with lines—scribbles, funny faces, lettering, anything—to get a feeling of freedom. Even if you think you have a gift for tiny delicate line drawings with a fine pen or pencil, this is worth trying. It will act as a 'loosening up' exercise. The results may surprise you.

Be self-critical. If a drawing looks wrong, scrap it and start again.
A second, third or even fourth attempt will often be better than the
first, because you are learning more about the subject all the time.
Use an eraser as little as possible—piecemeal correction won't help.
Don't re-trace your lines. If a line is right the first time, leave it alone—
heavier re-drawing leads to a dull, mechanical look.

Try drawing in colour. Dark blue, reddish-brown and dark green are
good drawing colours. A coloured pencil, pen or chalk can often be
very useful for detail, emphasis or contrast on a black and white
drawing.

You can learn a certain amount from copying other people's drawings.
But you will learn more from a drawing done from direct observation
of the subject or even out of your head, however stiff and unsatisfactory
the results may seem at first.

A lot can be learned by practice and from books, but a teacher can be
a great help. If you get the chance, don't hesitate to join a class—even
one evening a week can do a lot of good.

What to draw with

Carbon Pencil

Charcoal

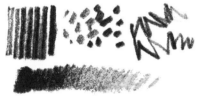

Wax crayon

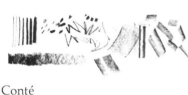

Conté

Oil pastel

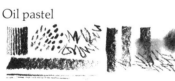

Soft chalk pastel

Pen and ink

Pencils are graded according to hardness, from 6H (the hardest) through 5H, 4H, 3H, 2H to H; then B, through 1B, 2B, 3B, 4B, 5B up to 6B (the softest). For most purposes, a soft pencil (HB or softer) is best. If you keep it sharp, it will draw as fine a line as a hard pencil but with less pressure, which makes it easier to control. Sometimes it is effective to smudge the line with your finger or an eraser, but if you do this too much the drawing will look woolly.

Charcoal (which is very soft) is excellent for large, bold sketches, but not for detail. If you use it, beware of accidental smudging. A drawing can even be dusted or rubbed off the paper altogether. To prevent this, preserve your drawing with spray fixative. Charcoal pencils such as the Royal Sovereign are also very useful.

Wax crayons (also soft) are not easily smudged or erased. You can scrape a line away from a drawing on good quality paper, or partly scrape a drawing to get special effects.

Conté crayons, wood-cased or in solid sticks, are available in various degrees of hardness, and in three colours—black, red and white. The cased crayons are easy to sharpen, but the solid sticks are more fun— you can use the side of the stick for large areas of tone. Conté is harder than charcoal, but it is also easy to smudge. The black is very intense.

Pastels (available in a wide range of colours) are softer still. Since drawings in pastel are usually called 'paintings', they are really beyond the scope of this book.

Pens vary as much as pencils or crayons. The Gillott 659 is a very popular crowquill pen. Ink has a quality of its own, but of course it cannot be erased. Mapping pens are only suitable for delicate detail and minute cross-hatching.

Special artists' pens, such as Gillott 303, or the Gillott 404, allow you a more varied line, according to the angle at which you hold them and the pressure you use.

Reed, bamboo and quill pens are good for bold lines. You can make the nib end narrower or wider with the help of a sharp knife or razor blade. This kind of pen has to be dipped frequently into the ink.

Fountain pens have a softer touch than dip-in pens, and many artists prefer them.

Special fountain pens, such as Rapidograph and Rotring, control the

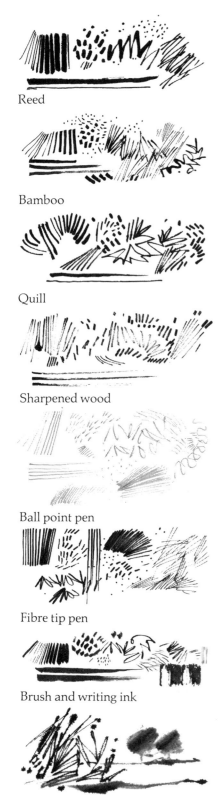

Reed

Bamboo

Quill

Sharpened wood

Ball point pen

Fibre tip pen

Brush and writing ink

Pen and brush on wet paper

flow of ink by means of a needle valve in a fine tube (the nib). Nibs are available in several grades of fineness and are interchangeable. The line they produce is of even thickness, but on coarse paper you can draw an interesting broken line similar to that of a crayon. These pens have to be held at a right-angle to the paper, which is a disadvantage.

Inks also vary. Waterproof Indian ink quickly clogs the pen. Pelikan Fount India, which is nearly as black, flows more smoothly and does not leave a varnishy deposit on the pen. Ordinary fountain-pen or writing inks (black, blue, green or brown) are less opaque, so give a drawing more variety of tone. You can mix water with any ink in order to make it even thinner. But if you are using Indian ink, add distilled or rain water, because ordinary water will cause it to curdle.

Ball point pens make a drawing look a bit mechanical, but they are cheap and fool-proof and useful for quick notes and scribbles.

Fibre pens are only slightly better, and their points tend to wear down quickly.

Felt pens are useful for quick notes and sketches, but are not good for more elaborate and finished drawings.

Brushes are most versatile drawing instruments. The Chinese and Japanese know this and until recently never used anything else, even for writing. The biggest sable brush has a fine point, and the smallest brush laid on its side provides a line broader than the broadest nib. You can add depth and variety to a pen or crayon drawing by washing over it with a brush dipped in clean water.

Mixed methods are often pleasing. Try making drawings with pen and pencil, pen and wash or Conté and wash. And try drawing with a pen on wet paper. Pencil and Conté does not look well together, and Conté will not draw over pencil or any greasy surface.

What to draw on

Try as many different surfaces as possible.

Ordinary, inexpensive paper is often as good as anything else: for example, brown and buff wrapping paper (Kraft paper) and lining for wallpaper have surfaces which are particularly suitable for charcoal and soft crayons. Some writing and duplicating papers are best for pen drawings. But there are many papers and brands made specially for the artist.

Bristol board is a smooth, hard white board designed for fine pen work.

Ledger Bond paper ("cartridge" in the UK) the most usual drawing paper, is available in a variety of surfaces—smooth, 'not surface' (semi-rough), rough.

Watercolour papers also come in various grades of smoothness. They are thick, high-quality papers, expensive but pleasant to use.

Ingres paper is mainly for pastel drawings. It has a soft, furry surface and is made in many light colours—grey, pink, blue, buff, etc.

Sketchbooks, made up from nearly all these papers, are available. Choose one with thin, smooth paper to begin with. Thin paper means more pages, and a smooth surface is best to record detail.

Lay-out pads make useful sketchbooks. Although their covers are not stiff, you can easily insert a stiff piece of card to act as firm backing to your drawing. The paper is semi-transparent, but this can be useful—almost as tracing paper—if you want to make a new, improved version of your last drawing.

An improvised sketchbook can be just as good as a bought one—or better. Find two pieces of thick card, sandwich a stack of paper, preferably of different kinds, between them and clip together at either end.

Examples showing the use of different surfaces appear here and on the next two pages.

Pen and ink on Bristol board.

Pencil on cartridge paper.

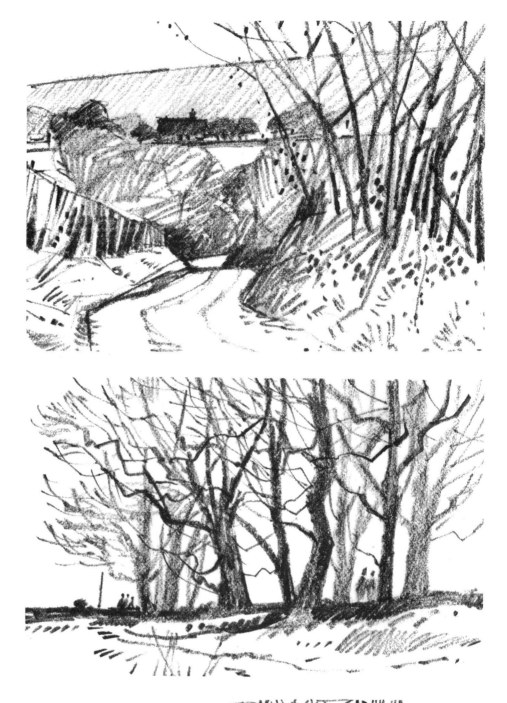

Pencil on Kent type paper.

Pencil on ordinary writing paper.

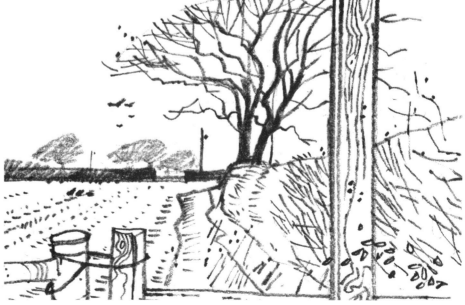

Pencil on watercolour paper.

Pencil on pastel paper.

Pencil on thin layout paper.

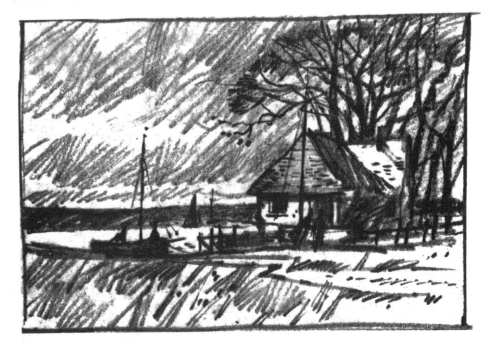

Perspective

You can be an artist without knowing anything about perspective. But most beginners want to know something about it in order to make their drawings appear three-dimensional rather than flat, so here is a short guide.

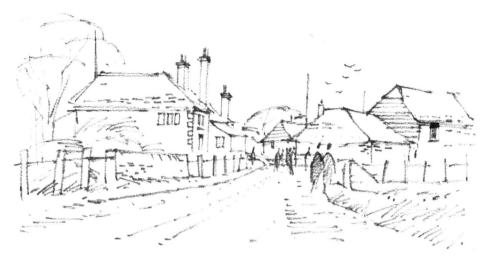

The further away an object is, the smaller it seems.

All parallel horizontal lines that are directly opposite you, at right-angles to your line of vision, remain parallel.

All horizontal lines that are in fact parallel but go away from you will appear to converge at eye-level at the same vanishing point on the horizon. Lines that are *above* your eye-level will seem to run downwards towards the vanishing point; lines that are below your eye-level will run upwards.

If the side of a building is facing you one vanishing point is enough; but if the corner is facing you, two vanishing points will be needed. It may even be necessary to use three vanishing points when your eye is well above or below an object, but these occasions are rare.

The larger and closer any object is, the bigger the front of it will seem to be in relation to the part furthest away, or to any other more distant object. Its actual shape will appear foreshortened or distorted.

Diagonal lines drawn between the opposite angles of a square or rectangle will meet at a point which is half-way along its length or breadth. This remains true when the square or rectangle is foreshortened. You may find it helpful to remember this when you are drawing surfaces with equal divisions—for example, a paved surface or the divisions between window panes—or deciding where to place the point of a roof or the position of windows on a façade.

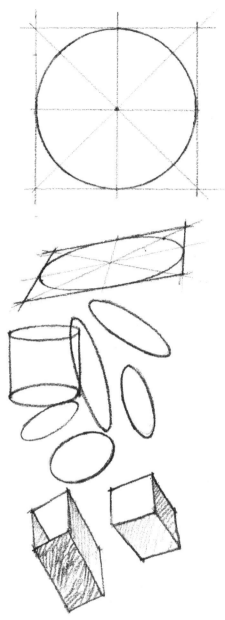

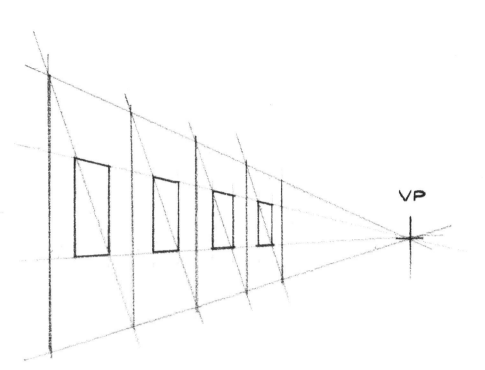

When drawing a circular shape, the following is useful: a circle drawn inside a square will touch the square at the centre point of each of its sides. A foreshortened circle will turn into an oval, but will still touch the centre points of each side of a similarly foreshortened square. However distorted the square, the circle will remain a true oval but will seem to tilt as the square moves to left or right of the vanishing point. The same is true of half circles.

At first you will tend to exaggerate the apparent depth of horizontal planes because you know they are square or rectangular and want to show this in your drawing.

You can check the correct apparent depth of any receding plane by using a pencil or ruler held at eye-level and measuring the proportions on it with your thumb. If you use a ruler you can actually read off the various proportions.

One point to mention again: *all* receding parallel lines have the same vanishing point. So if, for instance, you draw a street this will apply to all the horizontal edges—roofs, doors, windows, lines of bricks, chimneys.

Composition

This does not only apply to large, finished drawings. Even a quick sketch is helped by deciding how much of your subject to include and where to place it on the paper. Never distort your drawing in order to get the whole subject in, or you will wonder why it looks wrong.

If a subject interests you, then draw it, whether it makes a picture or not. You can improve the composition for a finished drawing by taking part of the sketch and making further adjustments, as in the sketch shown here.

An exploratory sketch should be done lightly in pencil so that corrections can be made easily without damaging the surface of the paper. If drastic alteration is needed, it is much better to start again.

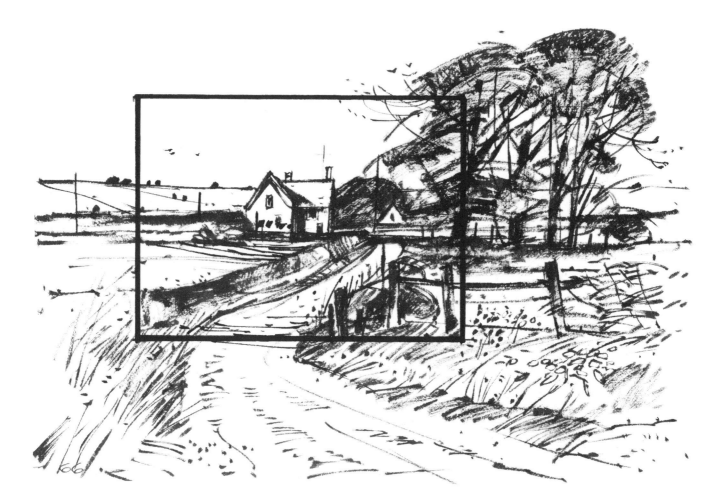

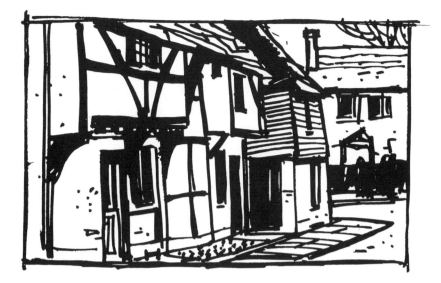

Mistakes in composition can be prevented by working out the scheme on a small scale first. The rough sketches here were done in my smallest sketchbook (3½ x 4 ins). In this way you can quickly establish a subject without loss of time. If the scheme does not work, try again.

You will find more examples of how to deal with composition in landscape drawing later in the book.

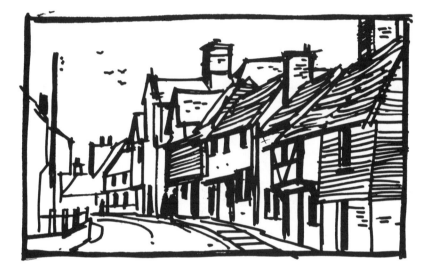

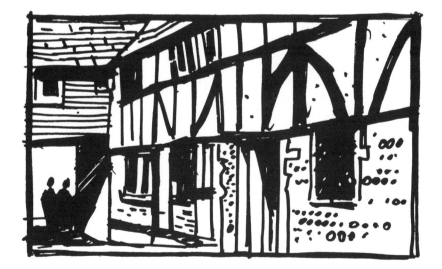

Where to draw

Take your sketchbook with you wherever you go. There is always plenty to draw.

One subject can be drawn from many different angles. This sawmill could provide enough subject matter for a dozen or more separate studies.

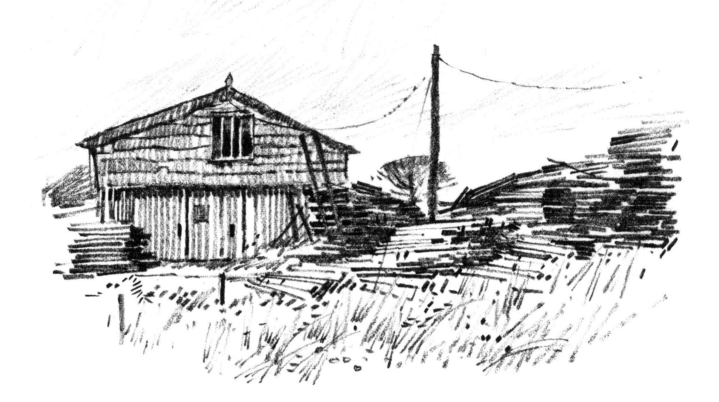

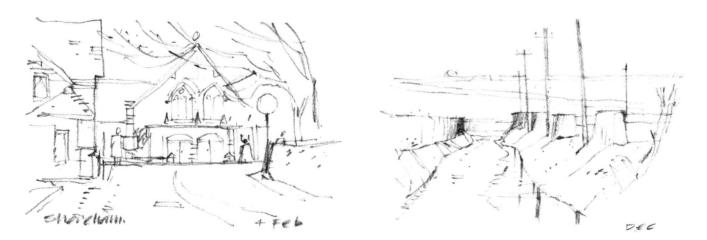

Two pages from my pocket-size sketchbook.

Structure

Structure in landscape is complex and involves everything from a leaf to the shape of clouds. Look for the underlying simplicity of the structure and ignore detail, which can be added later if essential.

Structural pattern of trees.

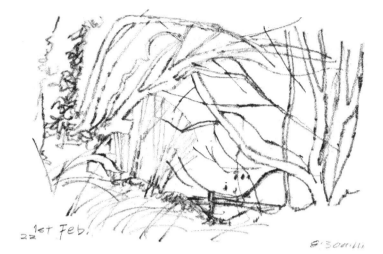

Use line to find the structure of your subject.

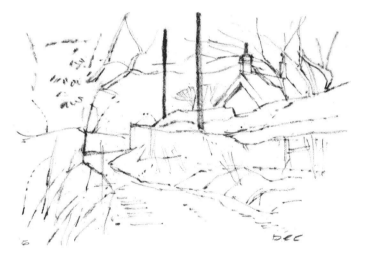

Form and structure defined by simple shading.

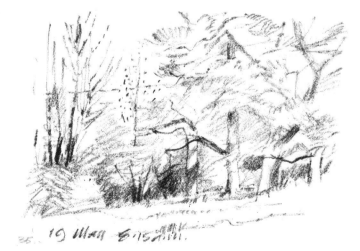

Where to begin

An apparently complicated subject can be simplified by your approach to it. I started this drawing with the most prominent vertical, the right hand pole, and then gradually built up the picture around it.

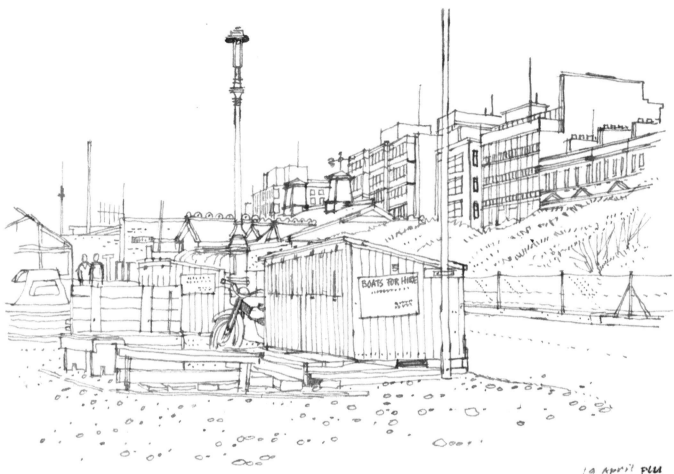

Hove promenade.

19 April PCU

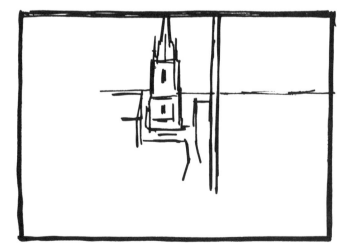
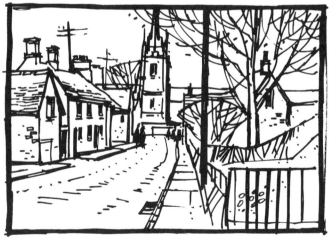

Another example of how to begin a sketch.

A complex drawing step by step

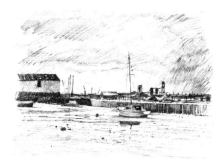

The following sequence of drawings shows how to build up a complex subject. First establish the horizon line and position of the main parts; this gives you the basic composition. All detail can be ignored until the drawing has developed. Draw lightly to begin with and try to avoid rubbing out.

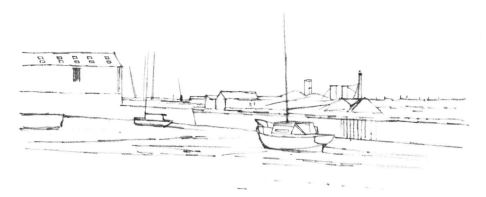

Now start to draw the principal elements, but still keep it simple. Look at the subject through half-closed eyes; this will reduce the complexity of detail to big shapes and make the task of drawing much easier. The first guide-lines are still visible.

A line drawing can be as complex as you like to make it, but sometimes, if carried too far, it loses the spirit of the subject. At this stage the drawing could be left as it is.

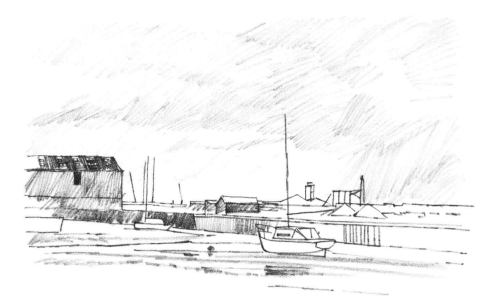

The sky is shaded first to establish its rough form. Only the main areas of the drawing are given tone. Avoid cross-hatching and try to indicate light and shade with bold, positive lines. Keep your work open and let the paper show through.

It is better to work to a logical sequence than to add to your drawing in a haphazard way.

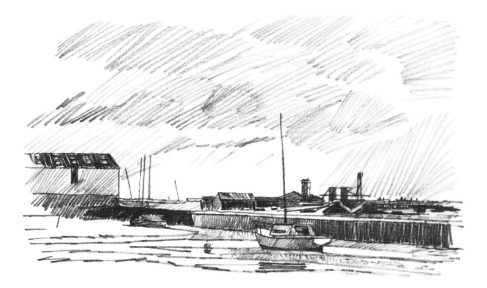

Careful placing of dark areas begins to bring the drawing to life. Try to get the correct contrast of dark and light as you work. If you have to keep going over the shading your drawing will lose spontaneity and freshness. The darkest parts are put in first, working around any lighter parts. Alternatively, start with the lighter areas and put the dark down last.

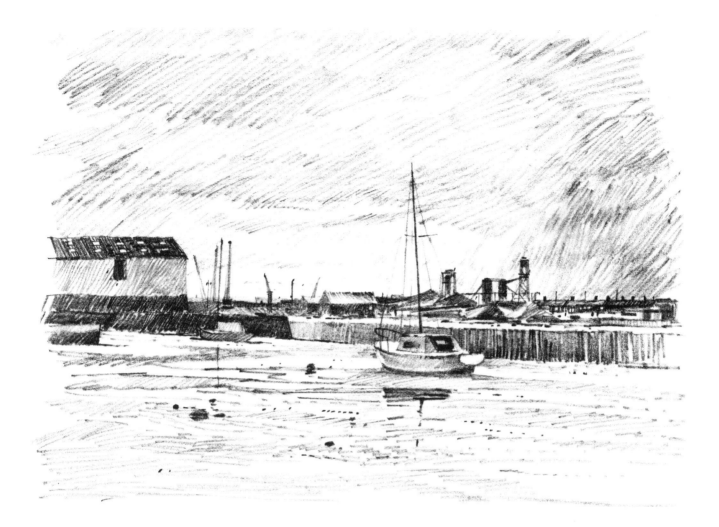

Detail can now be added, taking care not to overdo it. Here and there a tone needs darkening to create greater contrast, but I try to leave the drawing alone as much as possible. It is not always necessary or desirable to produce a fully toned drawing, but a great deal about tonal contrast can be learnt from doing so.

As sketches for a painting, steps 3 and 5 contain enough information to work from. These drawings are complete in themselves.

Drawing part of the subject

It is not necessary to draw everything you see. Leaving out one of the major features sometimes adds strength to a composition.

The cow parsley and the old barn provided sufficient interest here so I left out the pond in the foreground.

Carbon pencil on ledger bond (cartridge) paper.

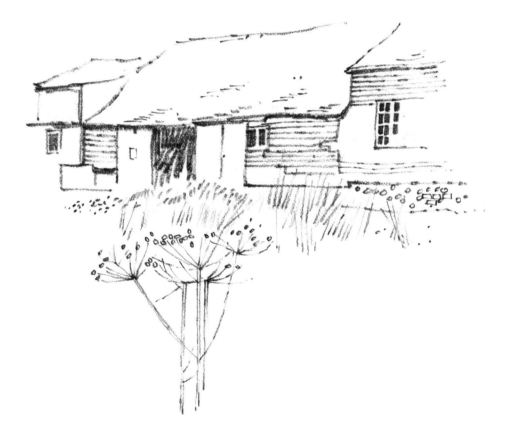

Part of a Cornish dry stone wall and a distant farmhouse are enough to capture the character of this rugged landscape.

Carbon pencil on ledger bond (cartridge) paper.

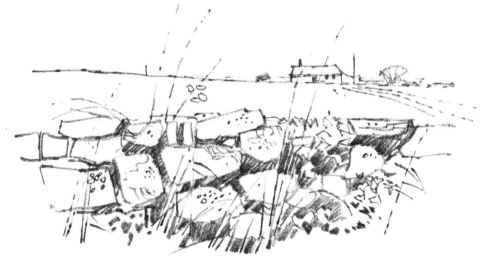

This disused bridge is in a dense wood. Too many verticals would take away the real focal point, so I have left out all the trees and emphasised the bridge and reflections.

Carbon pencil on ledger bond (cartridge) paper.

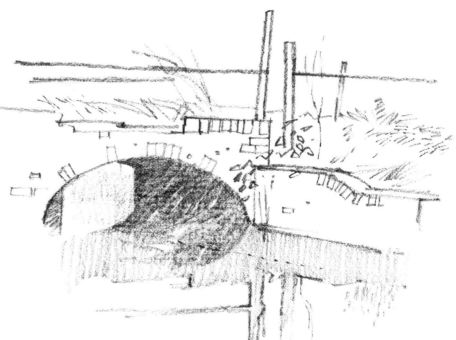

The lane near my studio has a number of interesting buildings. I selected the barn because it is typical of the local style. From this little sketch I developed an oil painting 30 x 20 ins.

Carbon pencil on ledger bond (cartridge) paper.

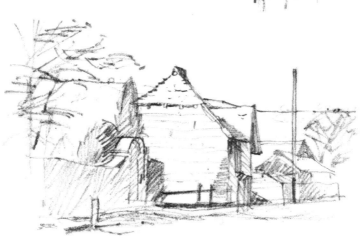

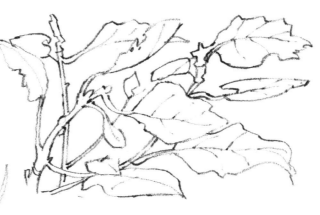

Plants are an essential part of landscape study. There is no need to tackle complicated subjects at first; you will get as much pleasure and practice from drawing a small part of the plant.

Pencil on ledger bond (cartridge) paper.

23

Using your sketches

Fill your sketchbooks with drawings of anything that interests you. Your confidence and ability will increase, and you will have plenty of reference material if you want to use your sketches later for a finished drawing or a painting.

Here are some pages from my sketchbooks.

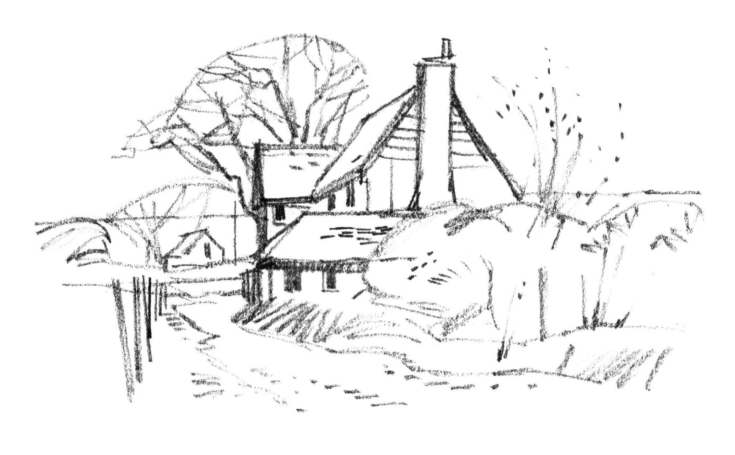

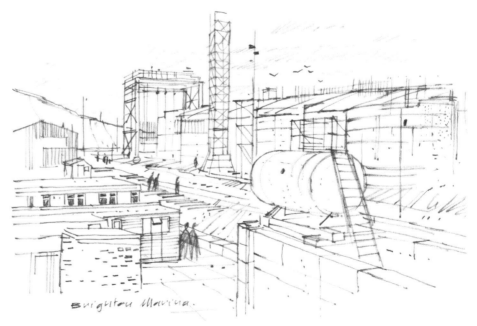

Brighton Marina.

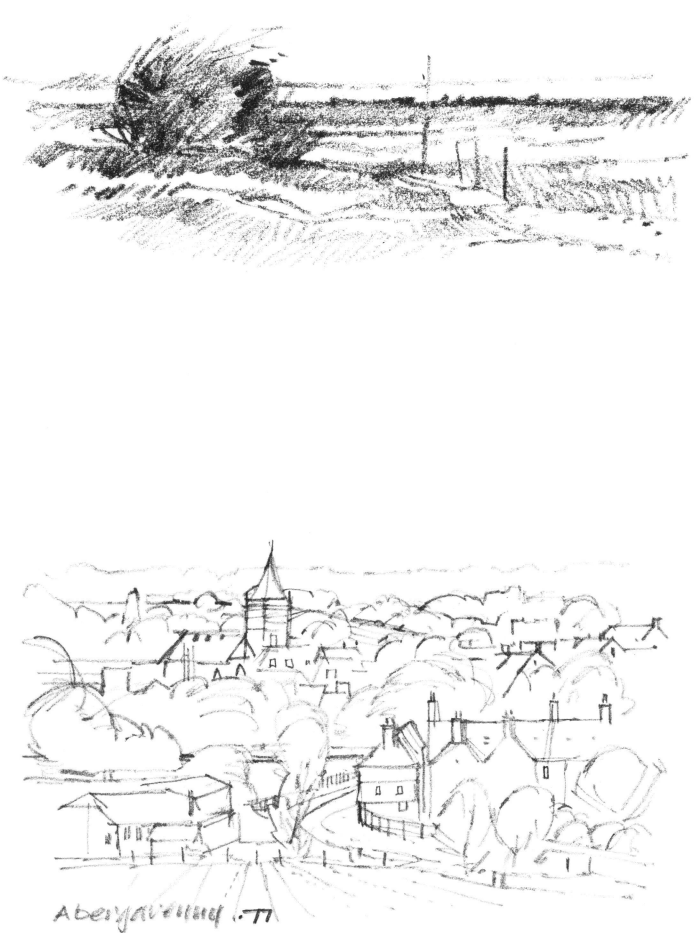

Abergavenny .77

Blocking-in and shading

To establish the essential factors, simplify your subject into large masses and ignore detail to begin with. You can then develop the drawing further by shading—but this is a matter of choice and sometimes unnecessary.

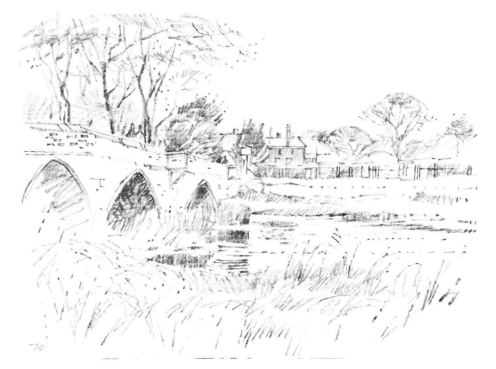

Pencil on ledger bond (cartridge) paper.

Simplification of a subject also clearly indicates its pattern value, which may be lost in the process of shading.

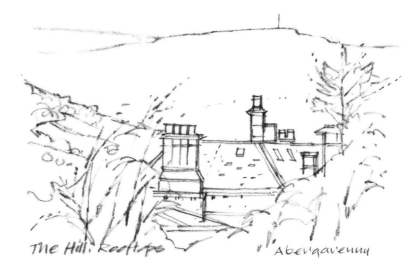

Conté pencil on ledger bond (cartridge) paper.

Conté pencil on illustration board.

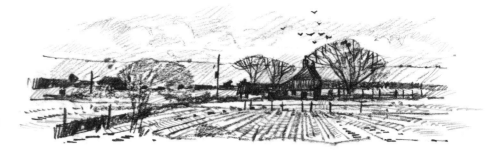

The silhouette of the distant church is the focal point and is given greater importance by shading. The line drawing shows how the subject is blocked-in. It is not always necessary to shade the whole of a drawing; empty areas play an important part too.

Pencil on ledger bond (cartridge) paper.

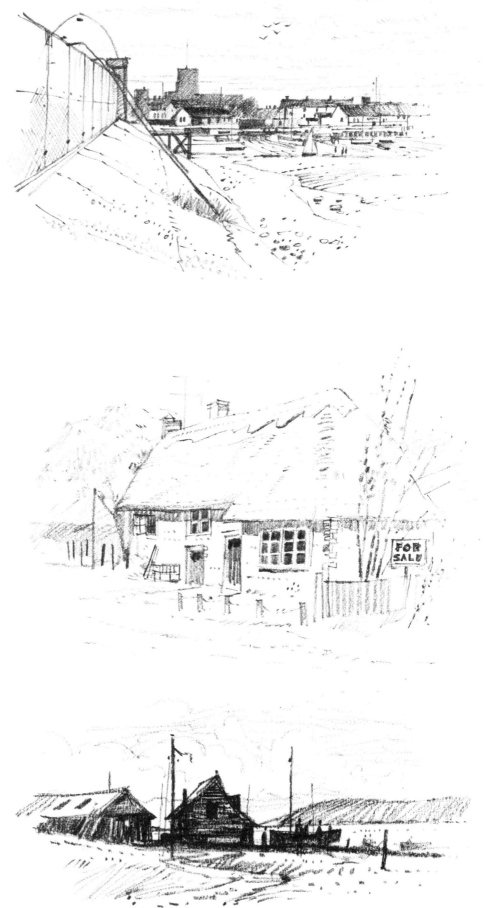

Shading here is minimal and only the darkest areas are picked out. Suggesting the texture of brick and thatch is enough to give solidity.

Carbon pencil on ledger bond (cartridge) paper.

Shading gives light, life and depth to a drawing. Here, the silhouettes of the boat and fishing sheds give a feeling of distance to the far cliffs.

Carbon pencil on card.

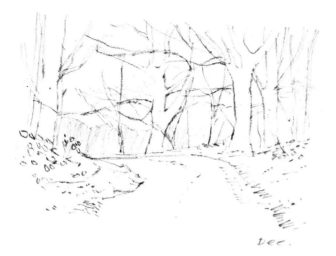

Shading in the distance suggests further trees, but notice also how the band of tone holds the drawing together.

Pencil on writing paper.

More pencil sketches to show how I approach drawing landscape out of doors.

Line drawings are often simple statements.

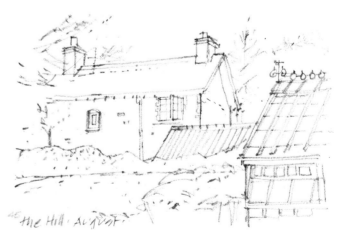

Shading in different tones gives the effect of recession. Practice making a simple tone scale in pencil, marking it off into four squares and putting down the lightest tone first.

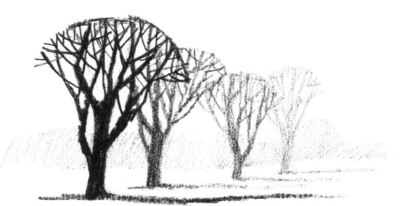

An imaginary drawing done in the studio using pencil, charcoal and pen. Shading in similar tones relates the foreground to the middle distance and the horizon.

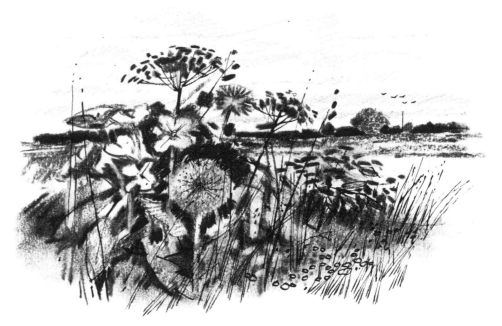

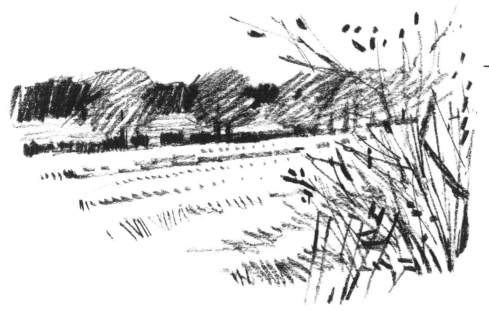

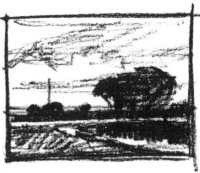

Getting life into a drawing

The effect of light and shade adds life to a drawing, and the contrasting tone values convey recession. For this drawing I used conté and white chalk on grey paper, making three tone values.

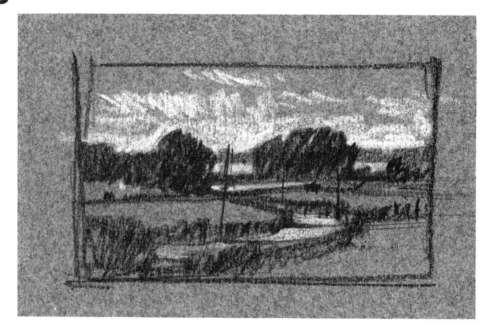

Two drawings of the same church illustrate how light and shade defines form, adding life and interest.

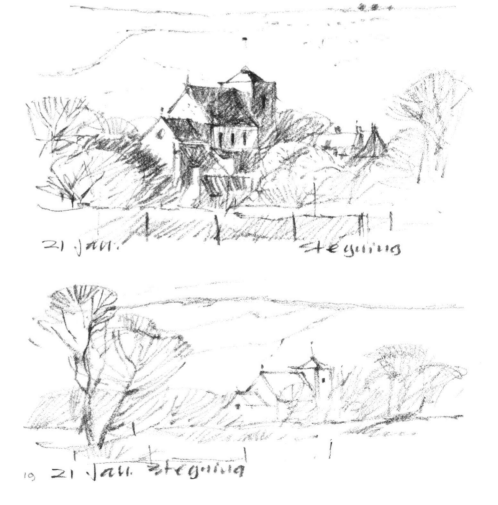

The quality of line you draw will improve naturally with experience and plenty of practice. Like good handwriting, it adds life to a page. To make your drawing more interesting, vary the thickness and intensity of line.

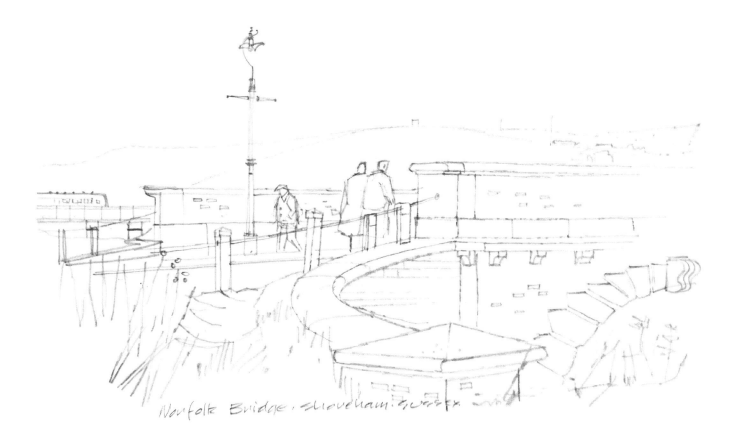

Norfolk Bridge. Shoreham. Sussex

Skies

Skies are very important in landscape drawing. When drawn well, they add life and atmosphere to even a small sketch. A common fault is to make the sky too dark so that it looks heavy and predominant. The sky is seldom darker than the land.

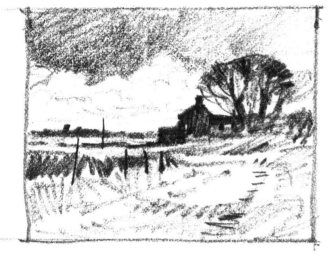

Carbon pencil.

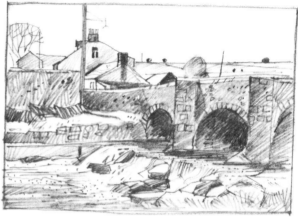

2B pencil.

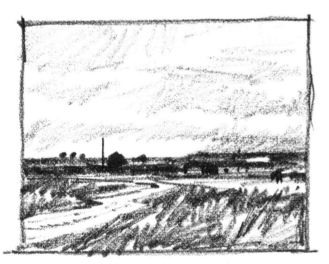

Carbon pencil.

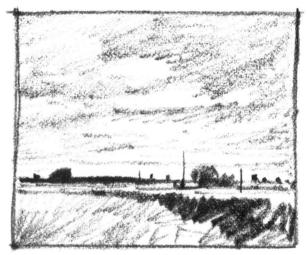

Carbon pencil.

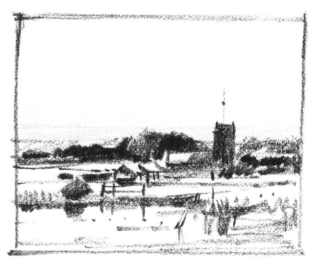

Carbon pencil.

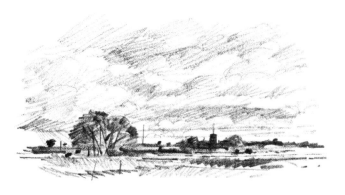

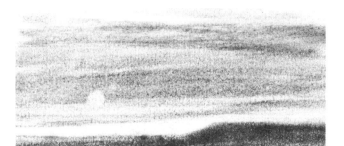

Imaginary sketches in pencil
and charcoal to show
different ways of treating sky.

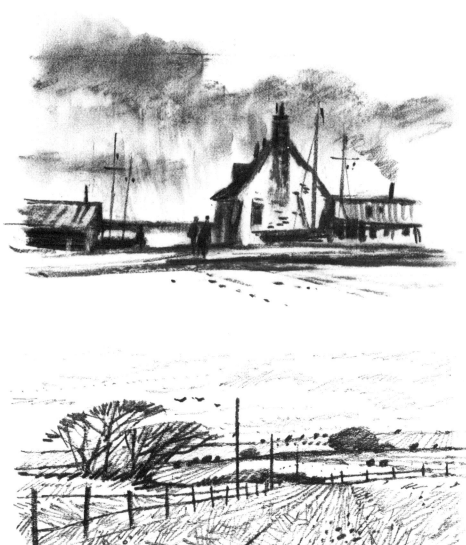

Demonstrations

I wandered around these oast houses looking for a suitable viewpoint. My first drawing, although it leads into the picture, has disrupting features. The oast caps are much too forceful and the ducting in the distance looks odd.

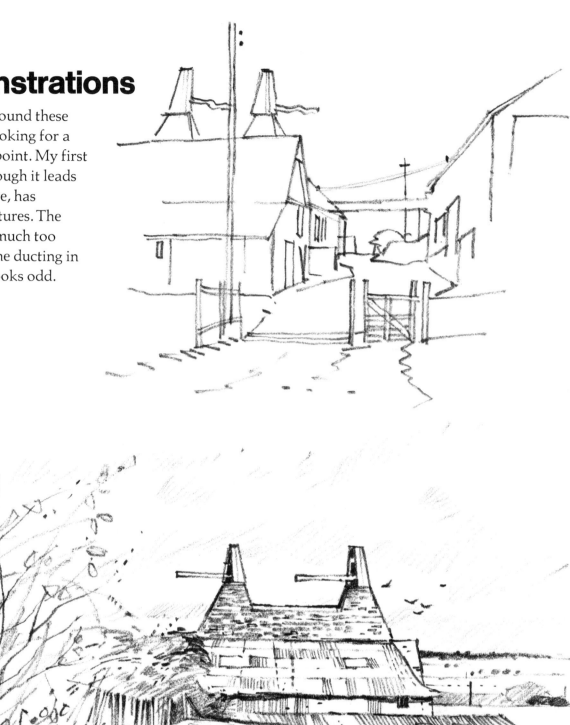

As I walked away down the lane I looked back and found a much better composition. The fence in the foreground gives a feeling of distance to the oasts.

Carbon pencil on ledger bond (cartridge) paper.

34

Stages in the development of a pen and ink drawing. Making a direct start without preliminary pencil blocking-in will strengthen your work and develop your style. Add details last of all.

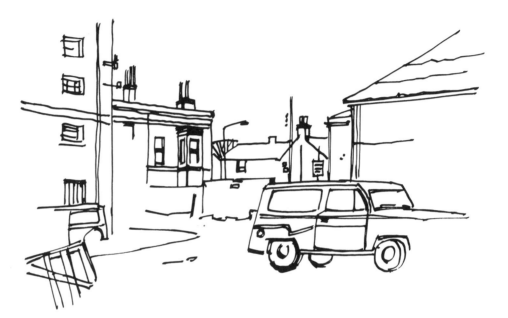

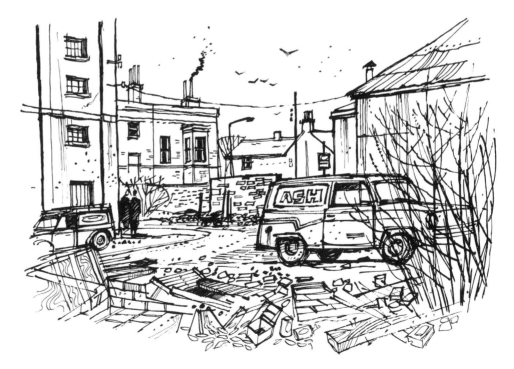

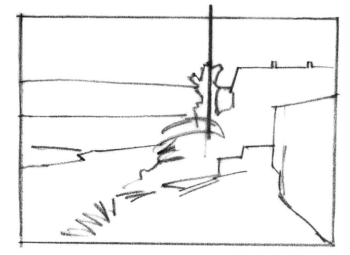
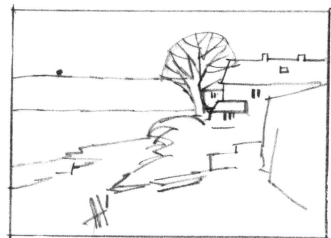

The most prominent part of this subject is the tree. It has been severely lopped and is an ugly shape. The vertical line in the first sketch places it well off centre. Adding branches gives a much softer effect and joins up the landscape.

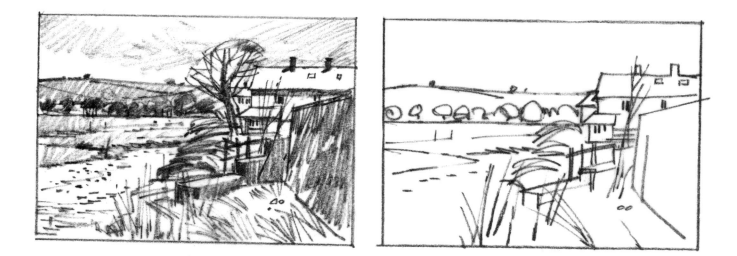

The finished sketch is a more satisfactory composition, and is reasonably accurate topographically.

In the drawing on the right the tree has been left out altogether. Although inaccurate topographically, the composition is greatly improved.

Pencil on ledger bond (cartridge) paper.

The immense height and grandeur of these cliffs make them an exciting subject. Scale is essential, and the figures on the promenade and cliff top give an indication of space and height. Without them it would be difficult to assess the scale.

Charcoal on paper.

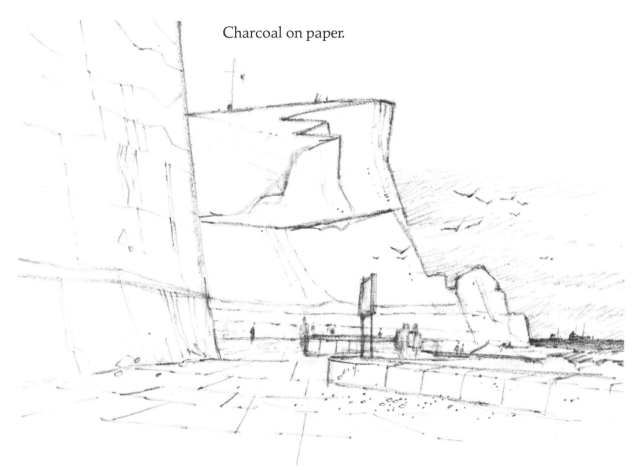

Getting the angles of perspective right is often a problem for beginners. Two pieces of card held together with a split paperclip can be a useful aid. Hold them up at eye level to the lines in question and adjust them to the correct angle.

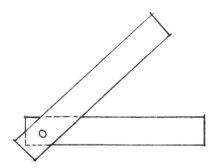

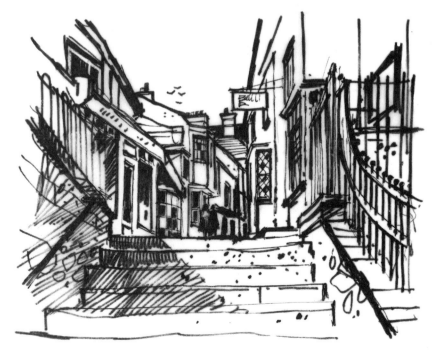

Choose a landscape theme, such as water, and discover what a variety of interesting subjects you can develop from it.

Carbon pencil.

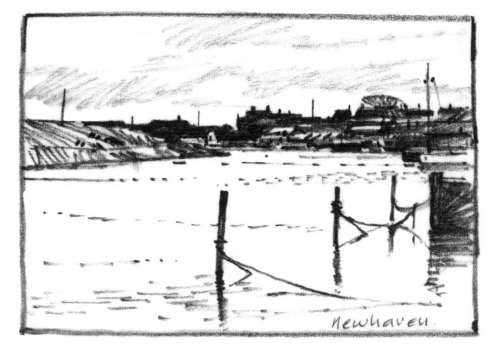

2B pencil.

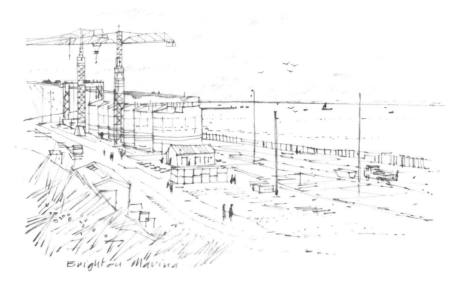

Carbon pencil.

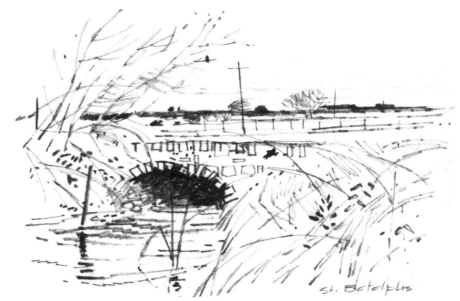

These drawings show how you can use tone and line to indicate recession and distance in landscape.

Four tone values are used in this charcoal study of a Cornish tin mine shaft. I first built up an overall middle tone, then applied the darker areas and finally lifted out the lighter values with a kneaded eraser.

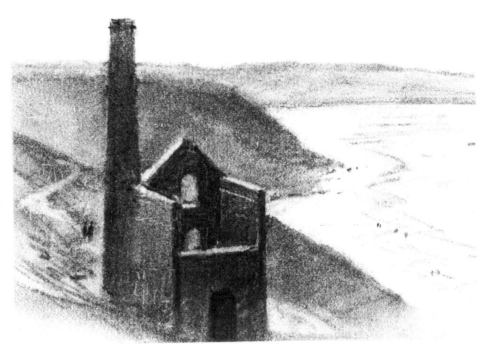

All receding parallel lines converge to an imaginary vanishing point. Here the main vanishing point is to the left of the cliffs, beyond the edge of the picture.

Brighton Marina.

Begin with a few tones and then add more as the drawing progresses. This is easier than trying for all the tones at once.

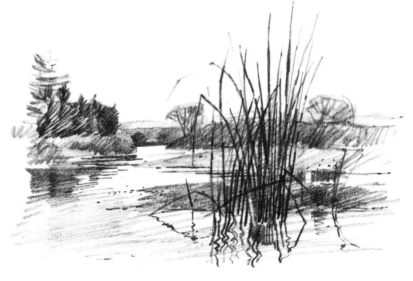

Media and techniques

Enjoy experimenting with different media and ways of using them.

For this drawing I have used willow charcoal for the foreground and carbon pencil for the seed in flight and the distant trees. Combination of the two media allows large masses of tone and finer detail.

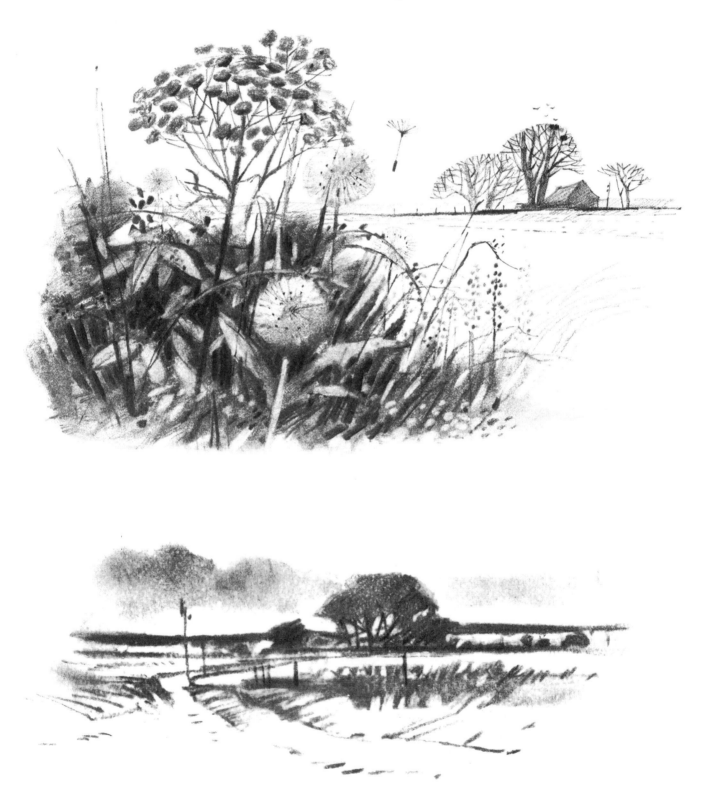

Some of the lighter parts of these charcoal drawings have been taken out with a kneaded putty eraser. This technique is useful for rapid impressions of light and shade. Do not apply the charcoal stick too heavily or it may stain the paper and be difficult to remove completely.

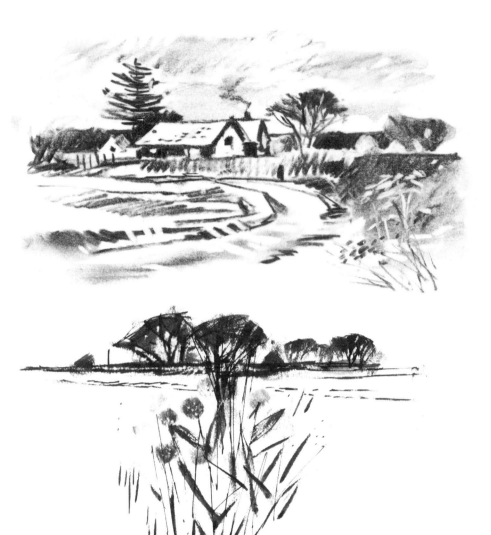

Drawn with a fountain pen and black writing ink and smudged while still wet. More drawing was added after the ink had dried.

The drawing on the right is a combination of broad and fine nibs and a sable brush, using black writing ink. This technique produces a contrast of line-width and texture.

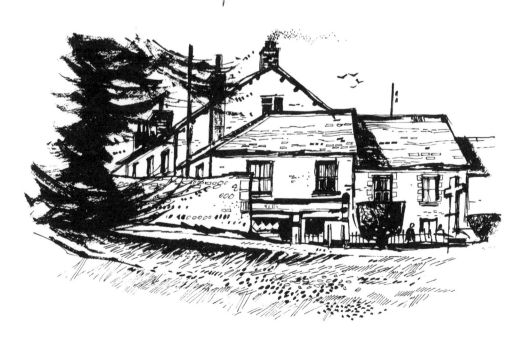

Different subjects in different media

If you do not mind being watched by interested passers-by, street scenes offer a wide variety of fascinating subjects and some good practice in drawing perspective. The ancient street near my studio was drawn direct with brush and writing ink on ledger bond (cartridge) paper.

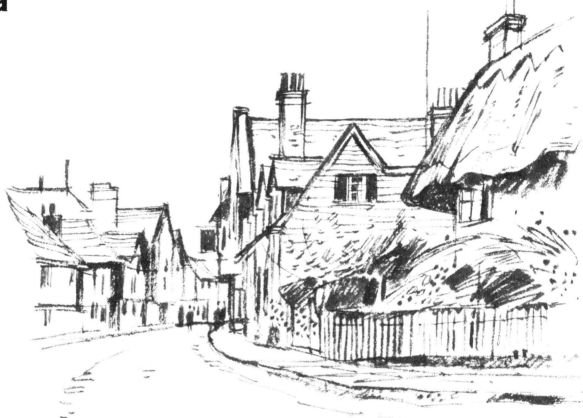

A charcoal drawing of fields, without any detail, providing enough information from which to develop a painting.

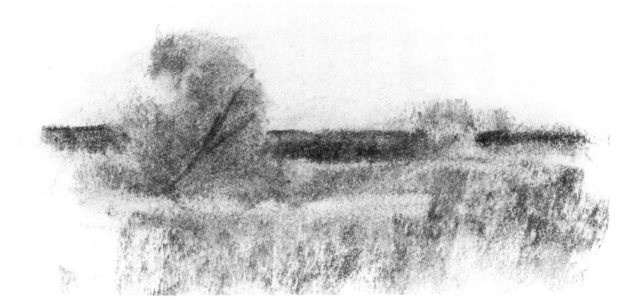

When starting a drawing, I decide first on the density of the darkest and lightest areas. I then work between that range.

Carbon pencil on ledger bond (cartridge) paper.

Drawing buildings will increase your knowledge of perspective and your appreciation of various textural surfaces. Compare the technique used here for illustrating the hedge, trees and roofs.

Fibre-tip pen on ledger bond (cartridge) paper.

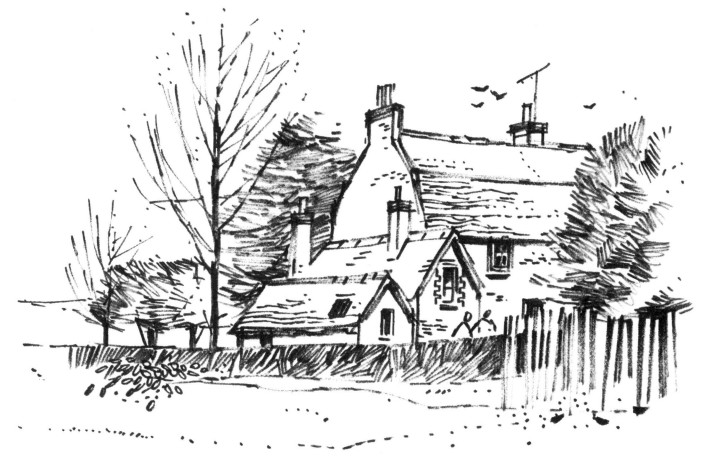

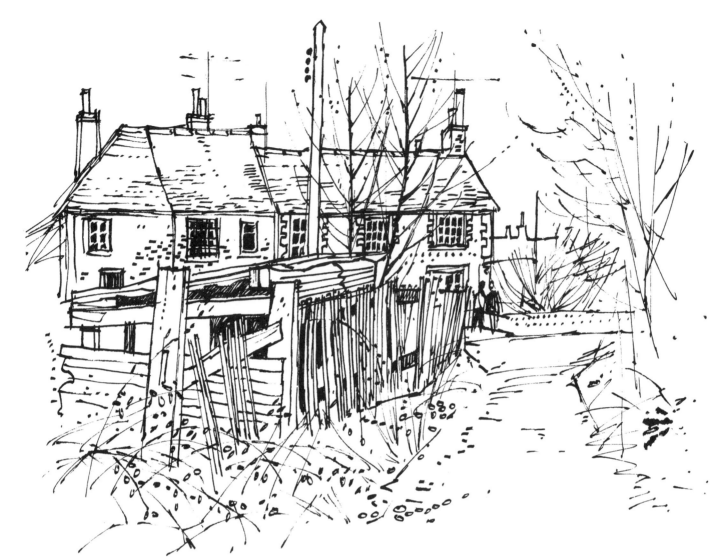

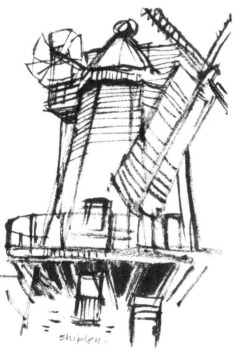

Pen and ink does not allow the same freedom of expression as other media but can produce a sensitive line and strong contrast. The drawing above was done direct without any preliminary pencil work, using a fountain pen and writing ink on ledger bond (cartridge) paper.

It does not matter if you cannot get the whole of your subject on to the paper. To get a complete view of this windmill I would have to have been a quarter of a mile away.

I started this drawing by indicating the top and bottom of the mill in relation to the page.

Drawn direct with brush and writing ink.

Three examples of the same
subject drawn in different
media.

Pen and ink

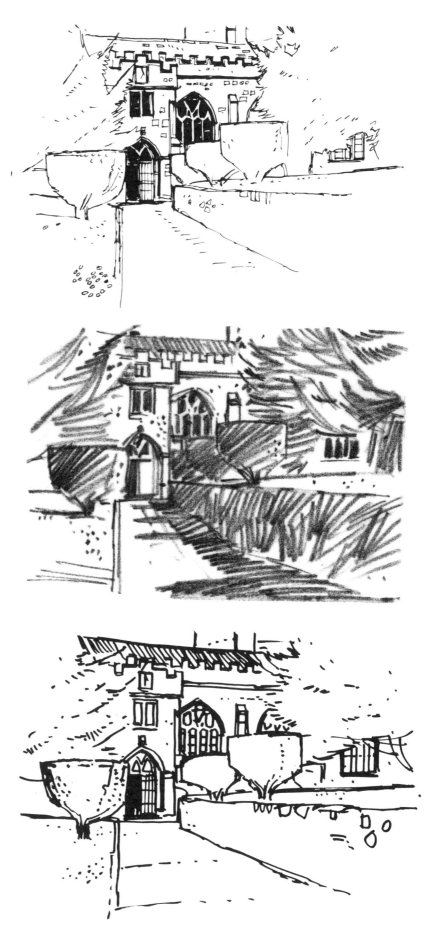

Carbon pencil

Brush and ink

Drawing a detailed subject in line is often more effective than attempting a tonal drawing. From this pencil sketch I have enough information to paint a picture. The drawing is also a complete statement.

I did this drawing of a country stile in dark brown oil colour pastel. Each mark must be positive because the pastel cannot be erased. I began with the left hand side of the sketch.

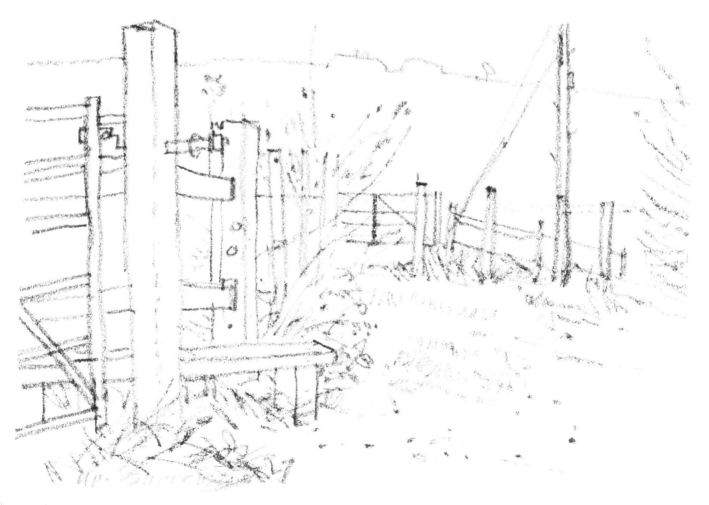

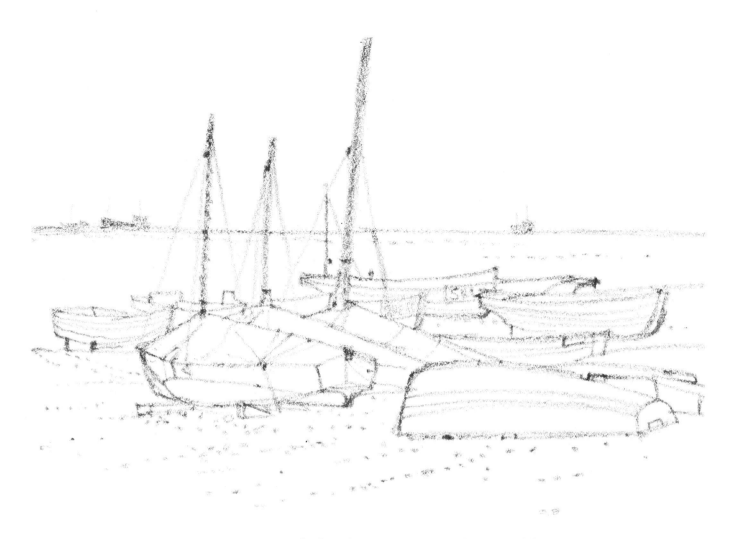

Boats on the beach are interesting shapes and form patterns when grouped together. Round sticks of oil pastel are not as good for fine line as square sticks, but broadness of expression is ideal for quick sketches.

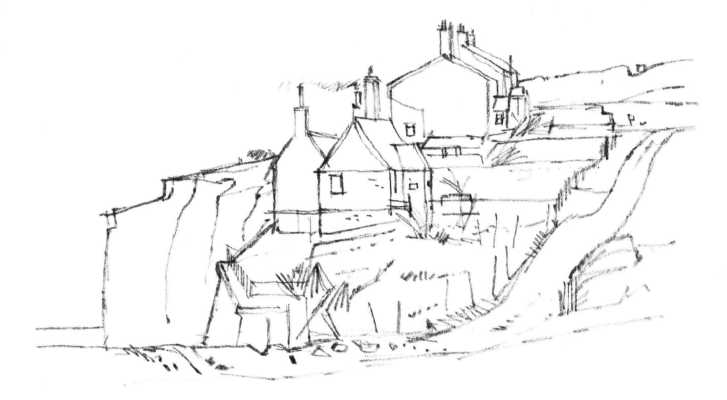

These coastguard cottages
rising majestically from the
cliffs are a very good subject
with a natural composition.

Conté pencil.